Artist Print #2, 2020

ISBN : 978-0-578-52711-6

Published by T Dot Eric LLC
www.tdoteric.com

RARE & UNSEEN MOMENTS OF 90'S HIPHOP

VOLUME ONE
SERIES 1.0 | SERIES 2.0

by

T. Eric Monroe

Thanks to everyone on the Publishing team who helped me so much, and a very special thanks to my family and friends who have been a part of this journey since the 90's.

featuring

TUPAC SHAKUR | BIGGIE SMALLS | LADYBUG MECCA

GURU | PARLIAMENT FUNKADELIC | RAEKWON

GHOSTFACE | BIG PUN | NAS

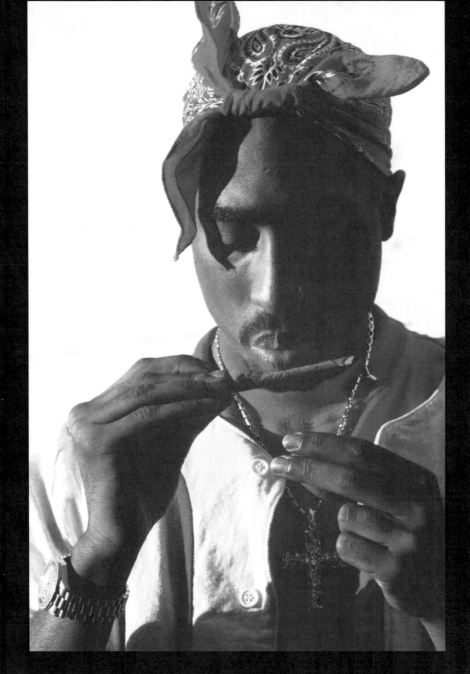

TUPAC SHAKUR

BLUNT DRY
HARLEM, NYC **1994**

I received a call from Tupac's
publicist (Interscope Records),
asking if I wanted to photograph
Tupac in Harlem.

The format of the segment,
Box Talk, was that camera
crews would shoot in front of
a location meaningful to the
artist. For Tupac, it was to be his
elementary school in Harlem.

"DEATH IS NOT THE
GREATEST LOSS IN LIFE.

THE GREATEST LOSS IS
WHAT DIES INSIDE WHILE
STILL ALIVE.

NEVER SURRENDER."

-Tupac Shakur

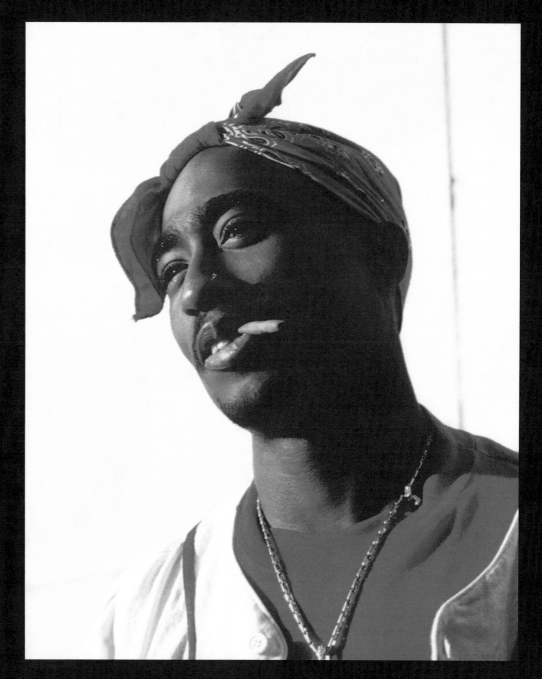

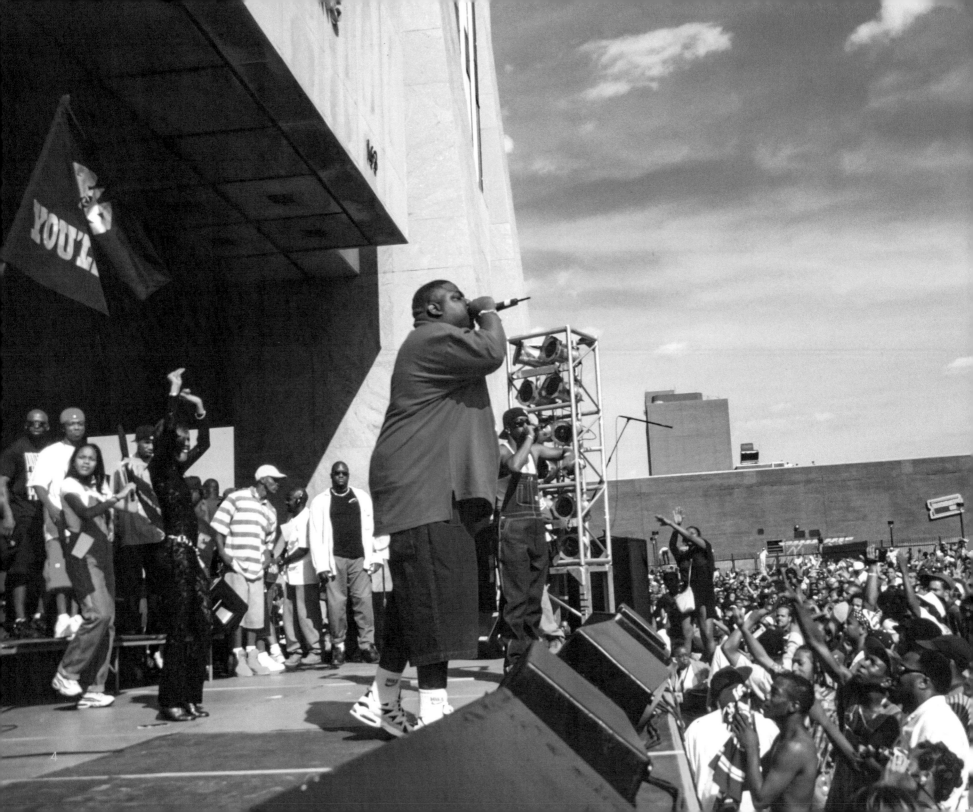

BIGGIE SMALLS

HOODSHOCK
HARLEM, NYC **1996**

The Notorious B.I.G. & Sean
"Diddy" Combs rocking the crowd
at "Hoodshock," the free outdoor
hiphop charity festival, in front of
the Harlem State Office Building
at 125th St. and Adam Clayton
Powell Jr. Blvd. in New York.

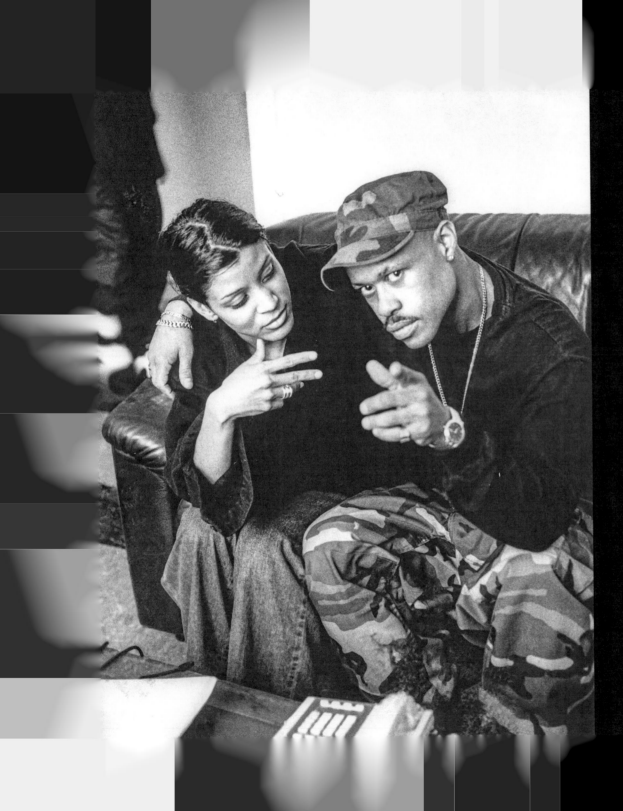

LADYBUG MECCA & GURU

BOROUGH CHECK
NEW YORK, NY **1994**

Guru & Mecca hanging in the studio during the recording of *Borough Check*, a track from Digable Planet's second album, *Blow Out Comb*.

NEW YORK CITY, **1994**

I was at the studio, observing Butterfly and their engineer as they worked to fix something on the soundboard. Guru (Gang Starr) opened the studio door and everyone lit up to greet him. Guru hugged Ladybug, gave a pound and hug to Doodlebug, and then to Butterfly. Butterfly then turned and pointed to me over in the corner; he started to introduce me to Guru. Guru, whom I had photographed a few times prior, cut-off the introduction, "Yo! That's my man, what!"

Guru asked what I was doing there. "Just hanging," I said, watching Digable as they worked, taking a few pictures. The afternoon went on. Guru worked in the studio writing his part for the song Borough Check, then joined Ladybug as she perfected her verses.

Watching Guru, Ladybug, Butterfly, and Doodlebug create a song in the moment was an fascinating process to watch. I wondered where they came up with the main hook, the chorus? How did they poetically tell a story, have it make sense, then add three more people to the song?

As enchanted as I was, I didn't stay for the recording of the song. I must have had somewhere to be. Before I left the studio, I was in the lounge, preparing to leave. Ladybug Mecca and Guru were seated on the couch across from me — not songwriting — just vibing, having a good moment.

I quietly took out my camera, waited a moment. Mecca looked into Guru. Guru looked into me. I took one picture, packed up my camera, and left for the afternoon.

THE MOMENT : LADYBUG MECCA & GURU

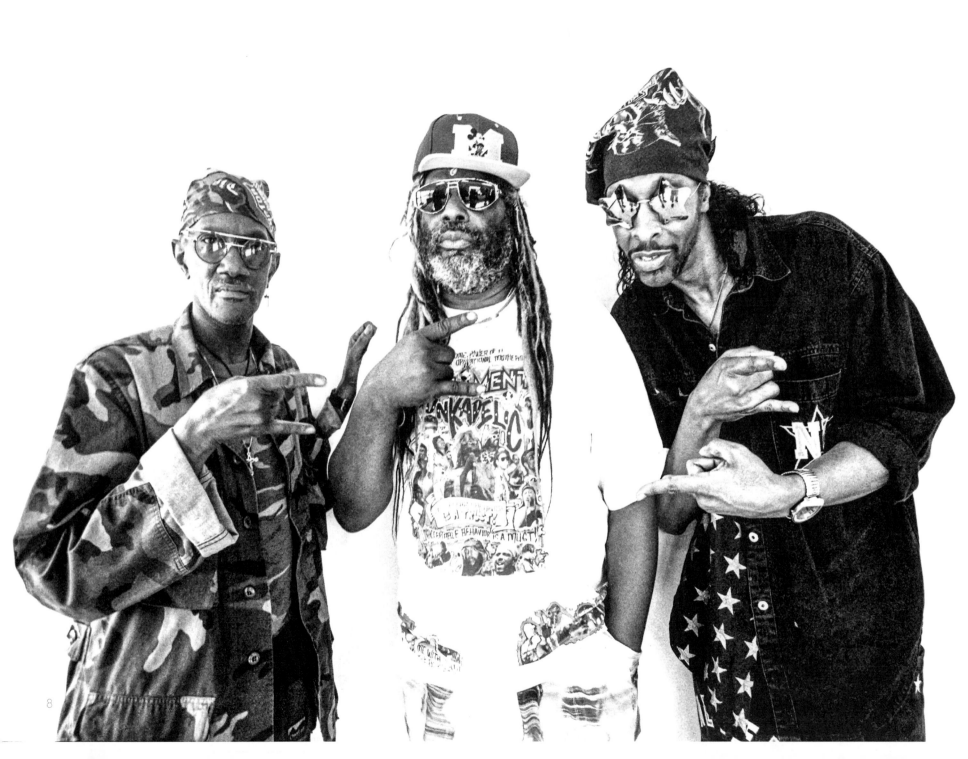

PARLIAMENT FUNKADELIC

P-FUNK
BERNIE WORRELL, GEORGE CLINTON, BOOTSY COLLINS
UPSTATE NEW YORK, **1996**

This was taken the first time De La Soul and P-Funkadelic ever met. Later that same day, they rehearsed, Knee Deep and *Me, Myself, and I* for their performance at Central Park's "Summer Stage: Return of the Mothership." De La Soul's 1989 hit *Me Myself and I* sampled Funkadelic's *(Not Just) Knee Deep* (1979), a pivotal sample looped throughout *Me, Myself, and I.*

RAEKWON

REFLECTIONS
NEW YORK, NY **1996**

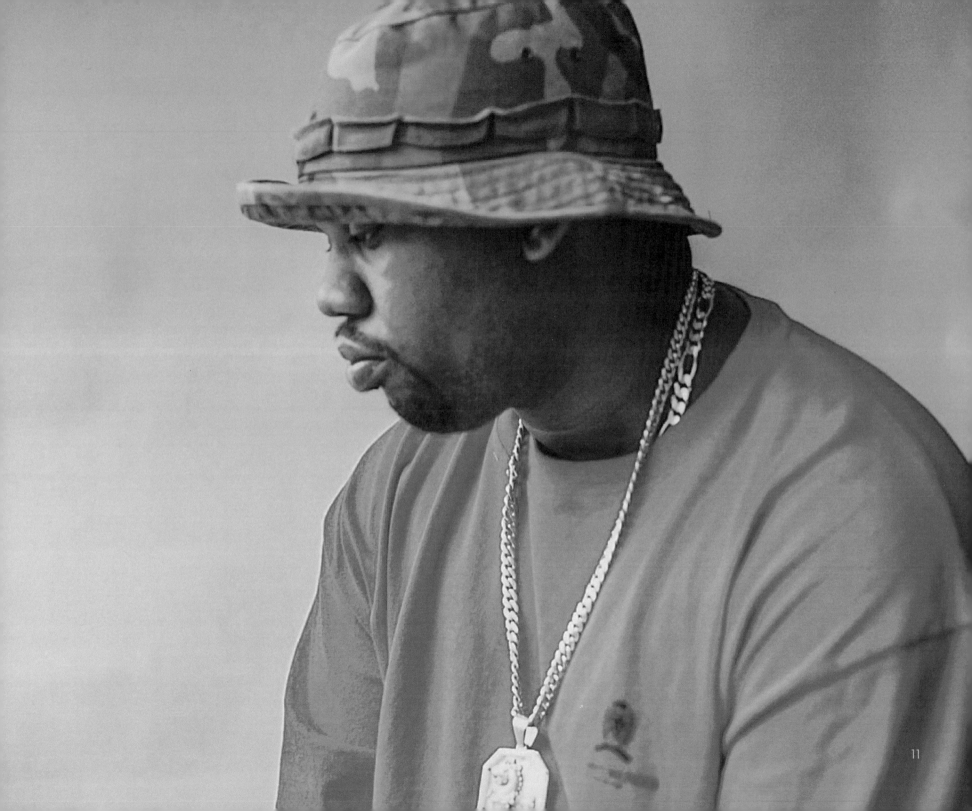

NEW YORK CITY, **1996**

I met Raekwon and Ghostface at the RCA Records offices, on West 47th & Broadway. Raekwon and Ghostface had just released their first duo album, *Only Built for Cuban Links*. Press and publicity were needed.

We walked out of the building and crossed the street, to a side entrance of Broadway's Palace Theater. The side of the building had a thick, cool layer of blackish-green paint with no lines, marks, or graffiti and was slightly covered by stairs traversing up the wall.

I'm not sure how we started shooting. It was just me and my Canon T-90 film camera. Manual focus. No filters. No lighting. No assistants. No make-up or wardrobe. Just us — young us.

We spent a few minutes by the wall. I set my bag down, got my camera together. They began to exchange gestures. As I raised my camera, they began to act and interact with each other for the shots. Yes, we got the "Yo' Son" pictures with hands in the camera lens, but there were also moments of deep personal reflection, showing the depth in Ghostface's eyes, the prowess of his first Jesus Piece gold medallion. There was an even more personal, reflective moment of Raekwon gazing into his own image in a window.

This shoot went beyond the typical "Yo, hip hop!" moments. These guys let me into their space, sharing their moments of true self outside of the brand character. They allowed me to capture their essence, making them - and each moment - timeless.

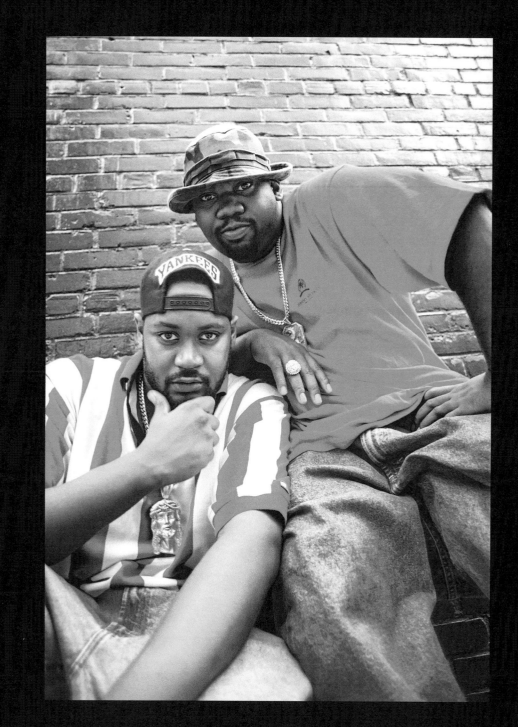

RAEKWON & GHOSTFACE

CHILLIN'
NEW YORK, NY **1996**

BIG PUN & SON

HOME
THE BRONX, NYC **1996**

I walked near the front steps. Pun was seated on the stairs in front of his porch, using the wireless house phone. Christopher came out of the house holding his father's Godfather hat, knowing his father liked to wear that particular hat in photo shoots. Pun continued his phone call. His wife at this point was at the doorway, behind the screened door, looking toward Pun's and Christopher's backs.

Pun finished the phone conversation. I could sense it was related to business and finances. He set down the phone, smiled, then leaned over to kiss his son as thanks for bringing his Godfather hat.

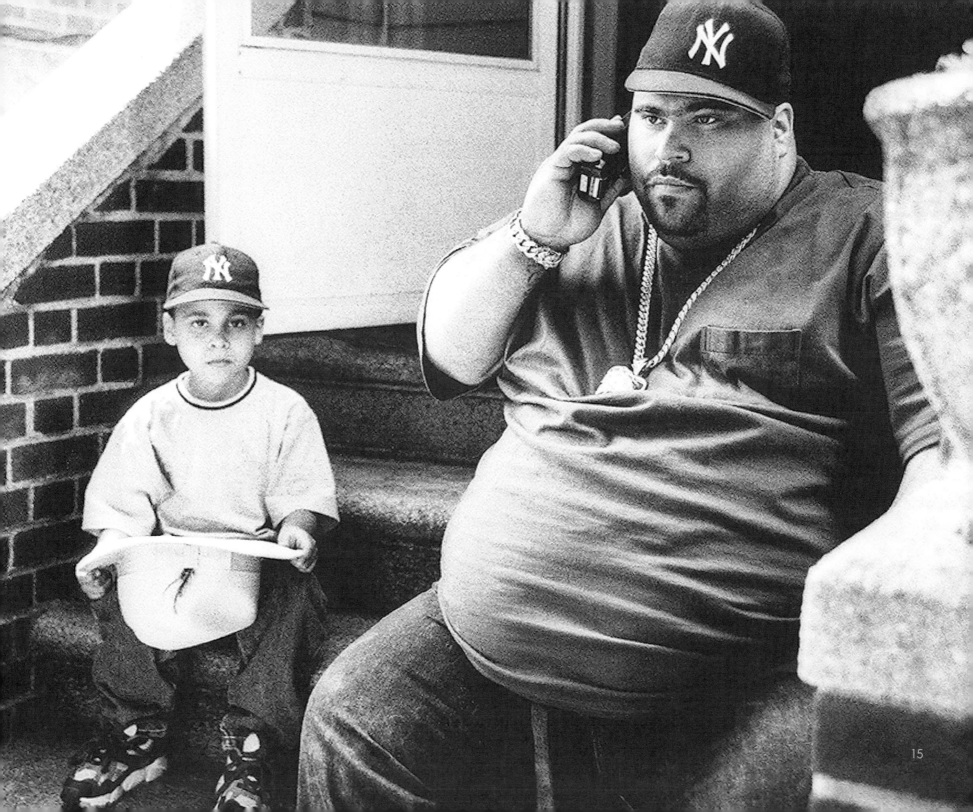

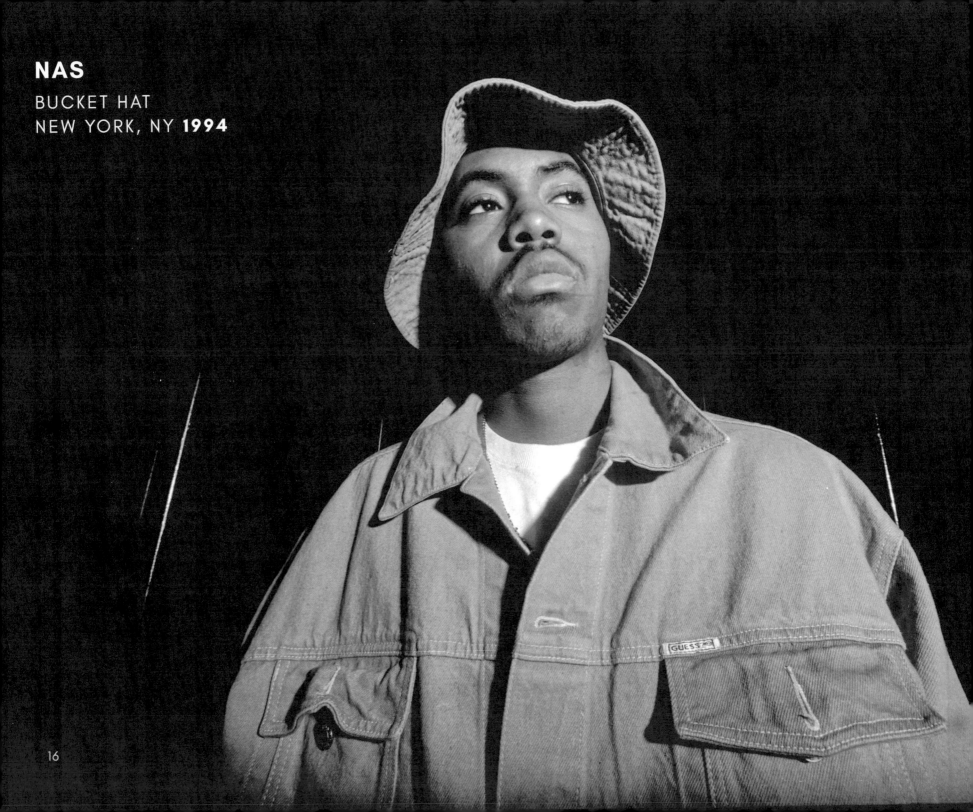

NAS

BUCKET HAT
NEW YORK, NY **1994**

16

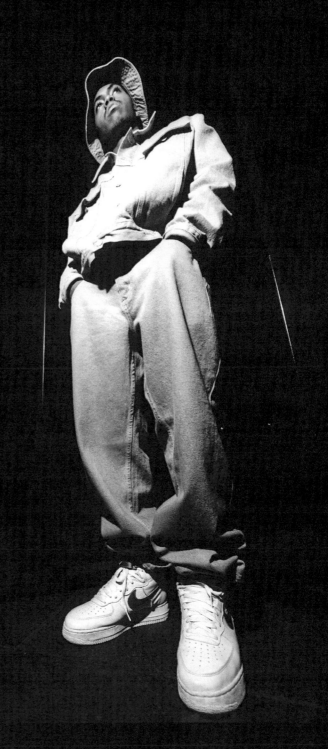

"THE SOUND OF THE

90'S, TO ME, IS A

COMBINATION OF

SOUL AND STREET –

IT'S A FEELING."

- Nas

SERIES 2.0

featuring

ERYKAH BADU | THE ROOTS | BIG L | GURU | JERU THE DAMAJA | TUPAC SHAKUR
BIG PUN & FAT JOE | LAURYN HILL | MOS DEF & TALIB KWELI | BOOTSY COLLINS
RZA | OL' DIRTY BASTARD | BIG POPPA

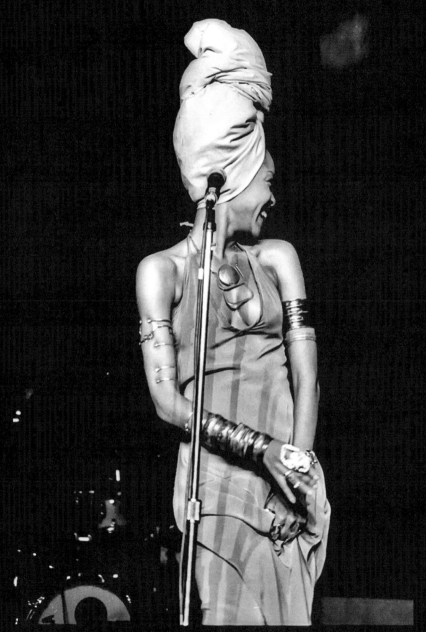

"PEACE AND BLESSINGS
MANIFEST WITH EVERY
LESSON LEARNED.

IF YOUR KNOWLEDGE WERE
YOUR WEALTH, THEN IT
WOULD BE WELL EARNED."

- Erykah Badu

NEW JERSEY, **1997**

ERYKAH BADU

POWER
NEW JERSEY, **1997**

The essence of power and
strength, Erykah Badu,
captured live in concert at
the PNC Bank Art Center
in Holmdel, NJ. She was
headlining "The Smoking
Grooves Tour" which also
featured A Tribe Called Quest
and The Pharcyde.

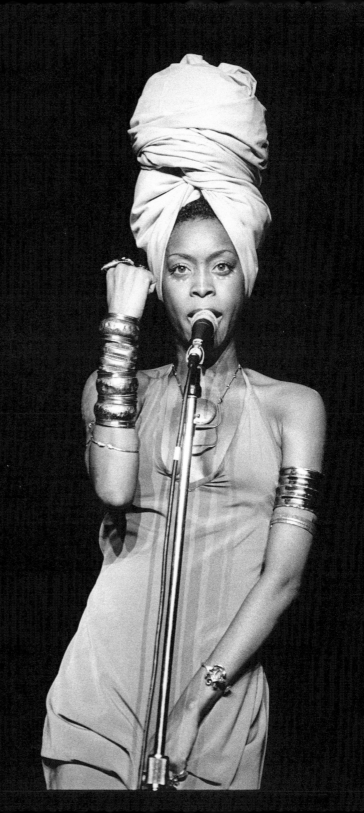

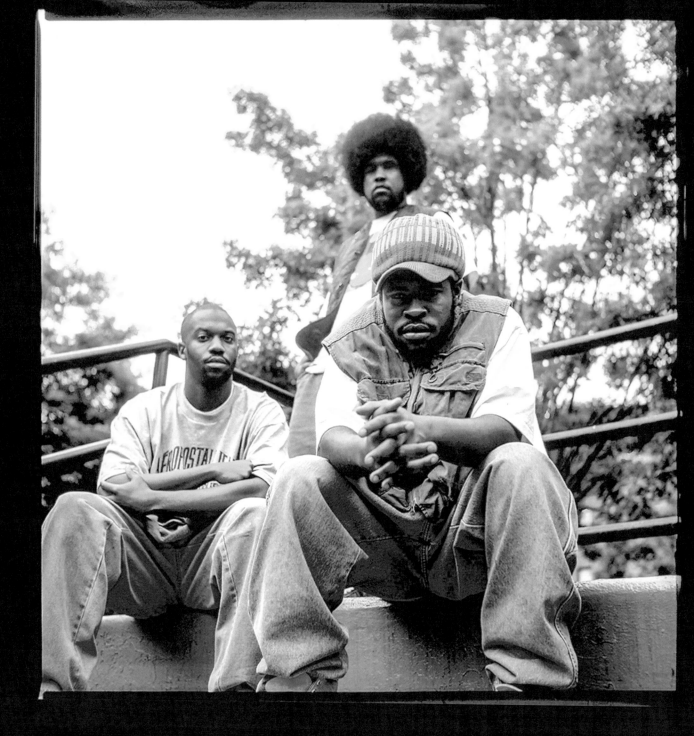

THE ROOTS

DO YOU WANT MORE
QUESTLOVE, BLACK THOUGHT, MALIK B.
NEW YORK, NY **1994**

We chose a park near Midtown Manhattan. I did not have a preconceived image I wanted to capture. We started out with some shots near a playground area. Then, we moved and sat on large cement steps or bleachers. Questlove, Black Thought, and Malik B. flowed in their space. I didn't direct them. I just wanted to capture them in their essence.

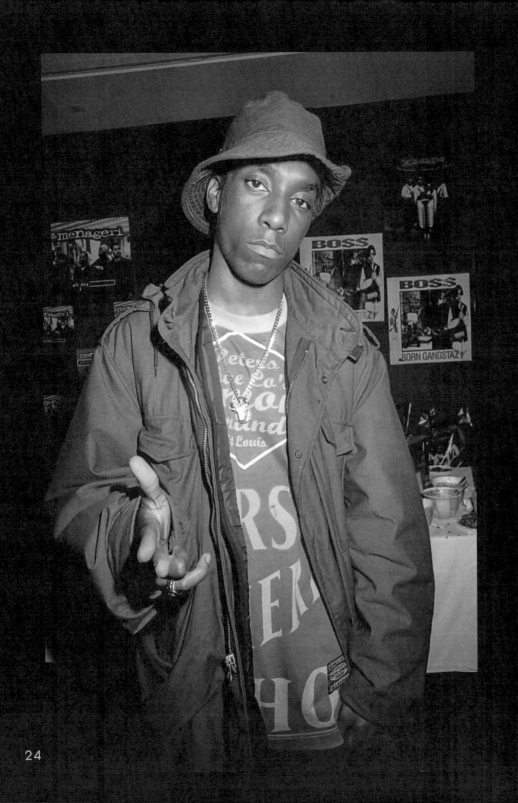

BIG L

L
NEW YORK, NY **1993**

"I KNOCKED OUT
SO MANY TEETH,
THE TOOTH FAIRY
WENT BANKRUPT."

- Big L

NEW YORK CITY, 1997

Over the years, I would regularly see Guru at industry functions. He was always nice, making sure I got all the shots I needed. We'd crossed paths enough times that Guru and I had become casual acquaintances.

It was springtime and I was making my rounds (photo lab, visits to magazines and record labels). I stopped by Empire Management to talk to one of my friends who handled publicity. For whatever reason, I asked what Guru was up to. He replied, "Oh, he's in the studio working on his Baldhead Slick project, you should stop by."

I got the address to Firehouse Studios where Guru was working and headed over. When I arrived, Guru's face lit up,"Yo, whatcha doin' here!" I explained I was just at Empire and they suggested stopping by and taking a few flicks.

Guru said, "COOL."

Realizing I might have distracted his vibe, I moved to the corner of the studio to stay out of eye-shot of Guru's working flow. After 20 minutes to a half hour of sitting around, I saw Guru was back in his zone. I got my camera out (Canon T-90), set a flash on a remote on the opposite side of the room.

I watched Guru work for a while longer. Every few minutes I would see a moment and take the picture (using one roll of black and white film).

At a certain point Guru pushed himself back from the soundboard and listened intently to what had been recorded. In that moment of watching Guru reflect on his music, I shot a few more frames, and knew I didn't need to shoot anymore.

I packed my camera bag, thanked Guru for allowing me a few moments, and headed out.

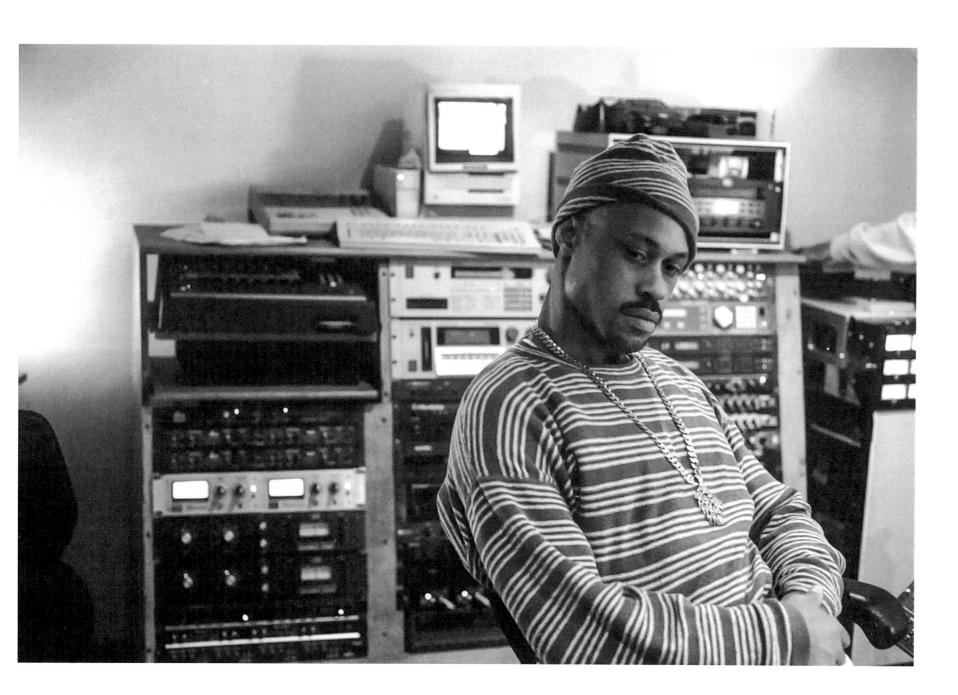

GURU OF GANG STARR

MOMENT OF REFLECTION
NEW YORK, NY **1997**

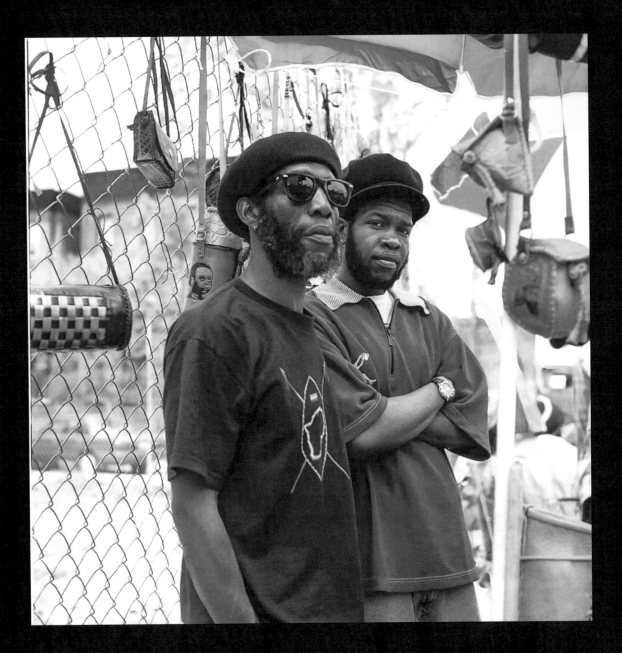

JERU THE DAMAJA & FATHER
FAMILY BUSINESS
EAST NEW YORK, **1993**

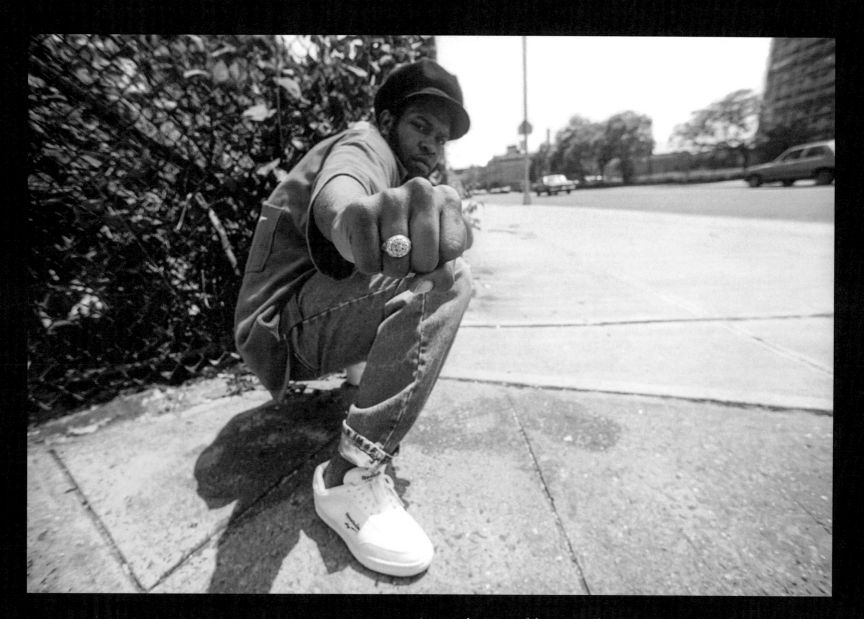

JERU THE DAMAJA

SUN RISES
EAST NEW YORK, **1993**

I was photographing Jeru the Damaja on spec for Thrasher Magazine. He showed me around his neighborhood and we shot a few moments of the street; then we went to visit Jeru's father, a leather craftsman who made shoes, handbags, and accessories. Jeru and his father had a great vibe; their love for one another came through in the pictures taken.

HARLEM, NYC **1994**

I watched for a while, then slowly got out my camera and moved toward some of the action. I was relatively close to Tupac and I kept to certain angles so I would not be intrusive in 'Pac's space. The connection became more endearing. At times, both of us looked at each other and quietly laughed at the media circus around us.

I was able to capture a personal vibe among Tupac and his friends — guys from the groups Thug Life and the Outlawz. After the main taping was done, the news cameras started to leave. The bulk of the news press got the shots they needed to portray Tupac as a "Dangerous Thug," which they would print in the next day's papers. It felt like Tupac knew how to play with the media to keep his name in the press. He knew how to press their buttons, challenge them mentally; their only recourse was to portray him as a troublemaker. The pattern was reactive and visible.

As more people left, Tupac and his friends stayed to themselves, lingering by one of the walls in the city park where filming had just concluded. They created a space and moment to relax together. Within that time, Tupac would peer beyond the edge of his red bandana, which dangled in front of his eyelashes as he prepared a blunt. As he finished, he kindly glanced at me. I got the shots I needed. I heard the lighter spark as I stepped away, giving them their personal space.

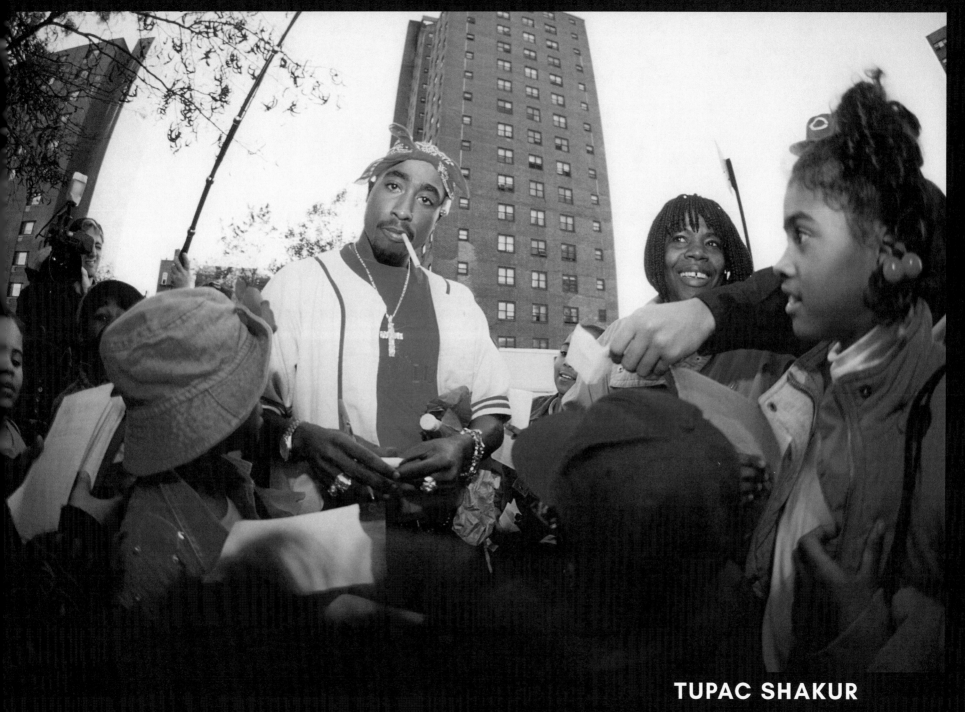

TUPAC SHAKUR
SIGNING AUTOGRAPHS
HARLEM, NYC **1994**

31

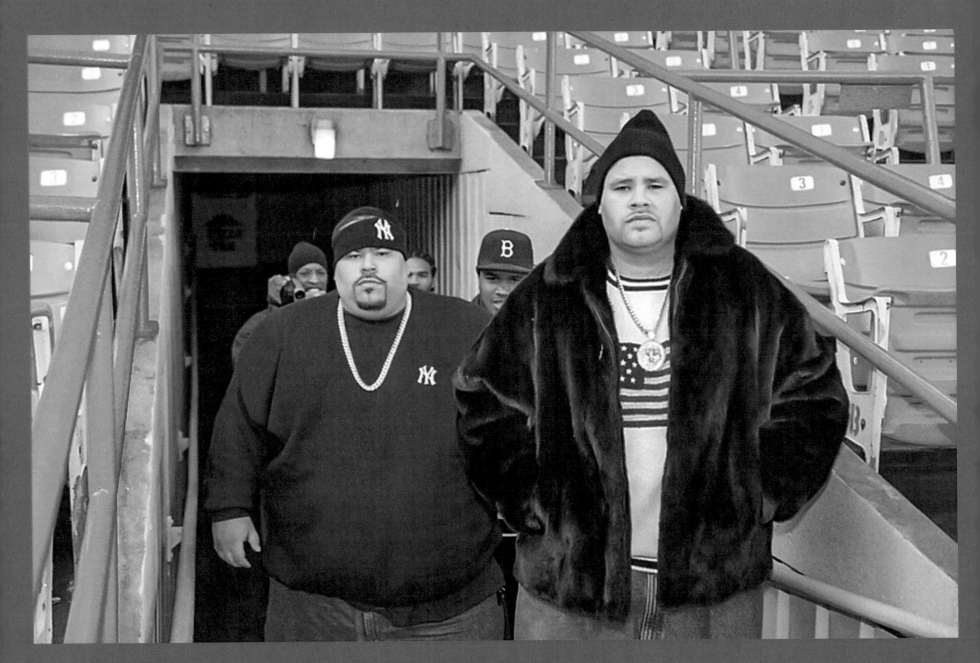

BIG PUN & FAT JOE
BLUE, SHEA STADIUM
QUEENS, NYC **1997**

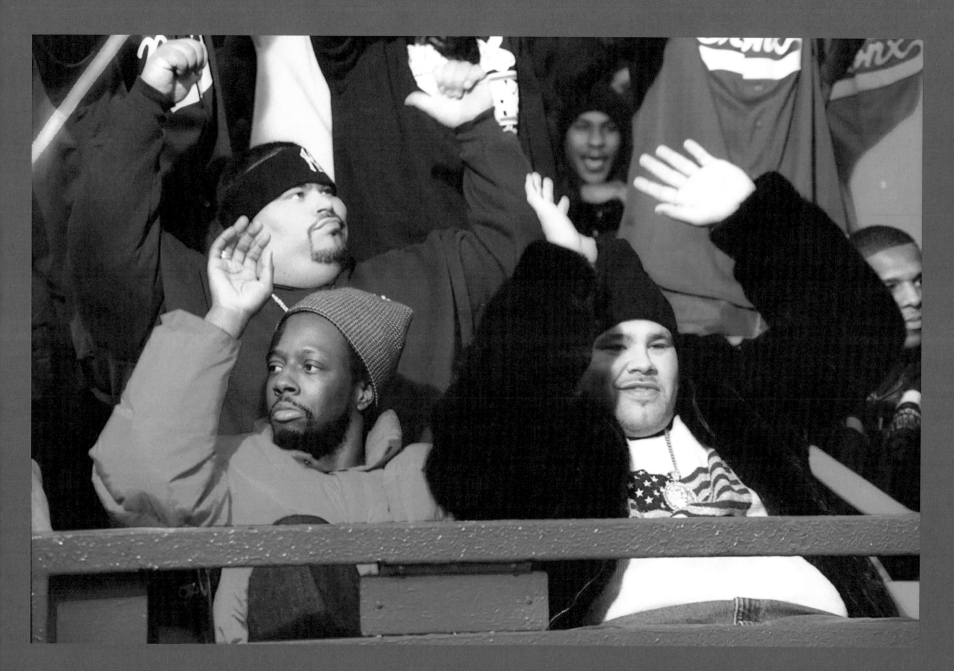

BIG PUN, WYCLEF JEAN & FAT JOE

THE CROWD, SHEA STADIUM
QUEENS, NYC **1997**

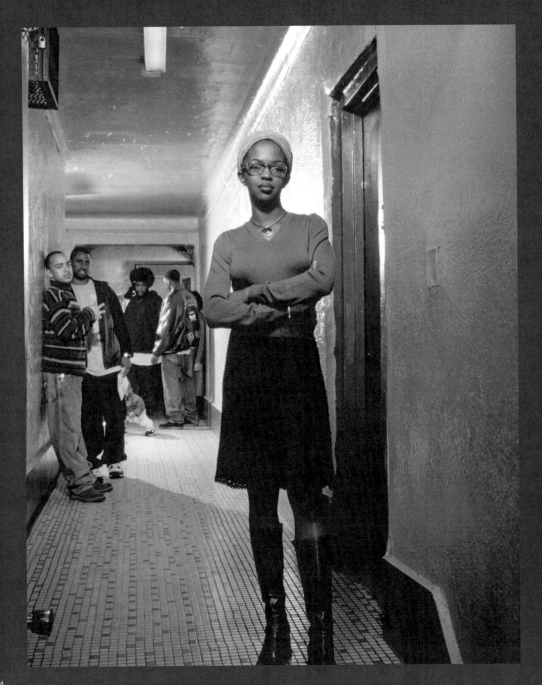

LAURYN HILL

HALLWAY
BROOKLYN, NYC **1997**

Lauryn Hill on set of of the
music video she directed for
Common's *Retrospect for Life*
as a duet with Lauryn Hill,
produced by NO ID & James
Poyser, from the album, *One
Day It'll All Make Sense*.

BROOKLYN, NYC **1997**

In addition to being featured on the song, Lauryn was chosen to direct the video. This video would be Lauryn's directorial debut, featuring cameos by Pete Rock, Black Thought, Mase (De La Soul), Questlove, and more, all in support of Lauryn and Common.

When I arrived on set, the taping of the video was in full swing. Lauryn and crew were handling all that needed to be accomplished, moving from scene to scene.

I had been watching Lauryn's progress since 1993. From the Fugees, to her solo album, to record production for others, it made sense to me that she could and would now be directing as well.

The shot of Lauryn in the hallway was captured between takes of the video. It was a moment of stillness; Lauryn just needed a moment to herself from within the chaos, but she still allowed me to remain in her space and photograph a few moments.

THE MOMENT : LAURYN HILL

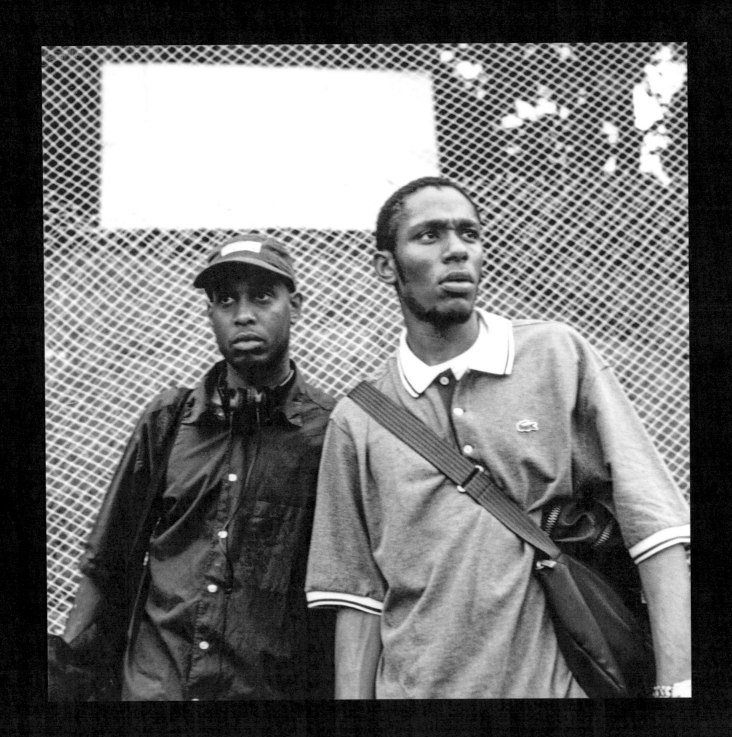

MOS DEF & TALIB KWELI

GET BY
THE BRONX, NYC **1998**

It was the Rocksteady Anniversary
Performance in the Bronx. I was walking
behind the stage to get a better vantage
point to shoot, when I saw Mos Def (Yasiin
Bey). When we saw each other, we greeted.
I used to see him every so often while De La
was working on *Stakes is High*, but at that
point it had been three years since we last
intersected.

Mos Def gestured that they were about to
go on stage. I motioned my hands, asking to
take one photo of him and Talib; they looked
at each other and agreed. I stepped back,
focused my Yashica Mat (124 G) camera, took
one shot and thanked them as they headed for
the stage.

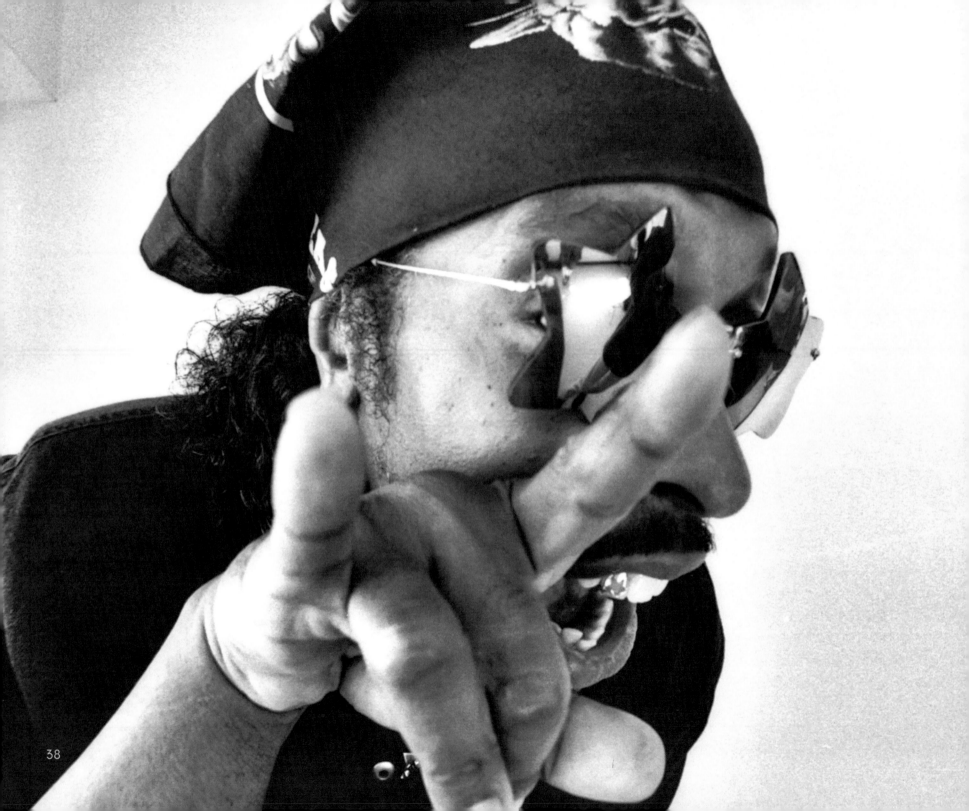

BOOTSY COLLINS

P-FUNK FINGERS
UPSTATE NEW YORK, **1996**

RZA

RINGS
NEW YORK, NY **1996**

"HAPPINESS IS SOMETHING

YOU GET FROM YOURSELF.

IF YOU'RE COMPLETELY

SATISFIED WITH YOURSELF,

NOBODY CAN TAKE IT AWAY

FROM YOU."

- RZA

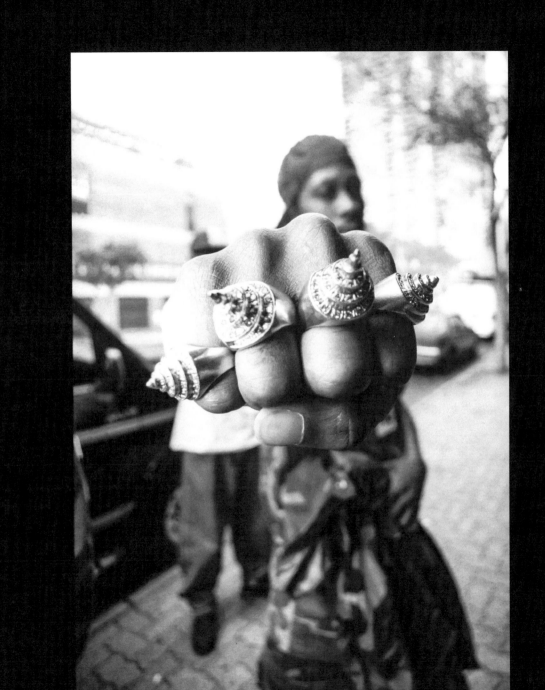

OL' DIRTY BASTARD

UNDER STARES
LOWER EAST SIDE, NYC **1995**

ODB and I walked and explored
the rooftop views of the
building, stopping every so
often as we felt a shot. At some
moments ODB went into his Ol'
Dirty Bastard character, and,
at other moments, he allowed
Russell Jones to peer through.

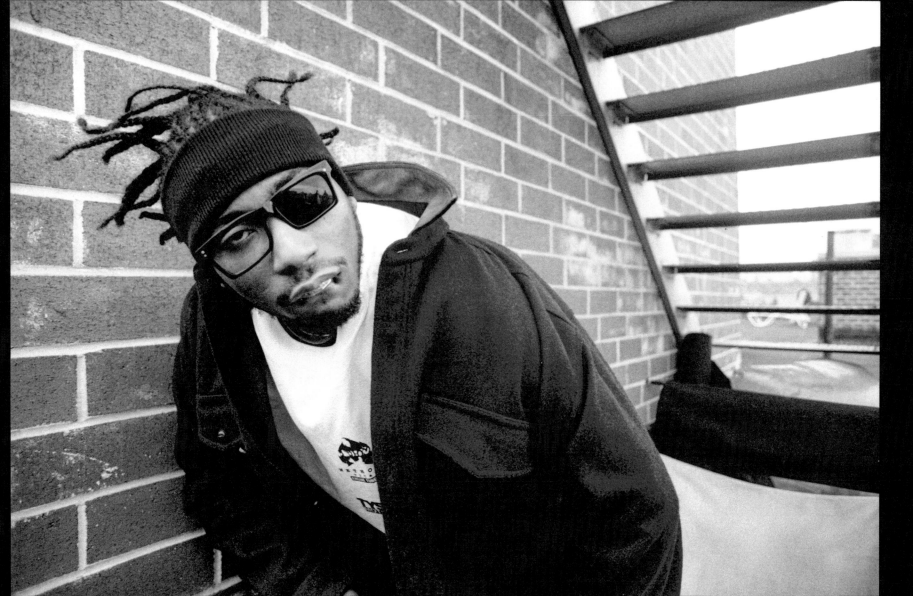

BIGGIE SMALLS

BIG POPPA
PHILADELPHIA, PA **1995**

The Notorious BIG captured in
performance at the filming of *The Show*
(the movie) in Philadelphia.

I wandered the set at first, running into a
few familiar faces. Soon enough, Biggie
started his performance with Diddy,
Lil Cease, and DJ Clark Kent. I walked
around to the front of the stage; Biggie
already had the crowd rocking with him.
Hit after hit, Biggie gave his all.

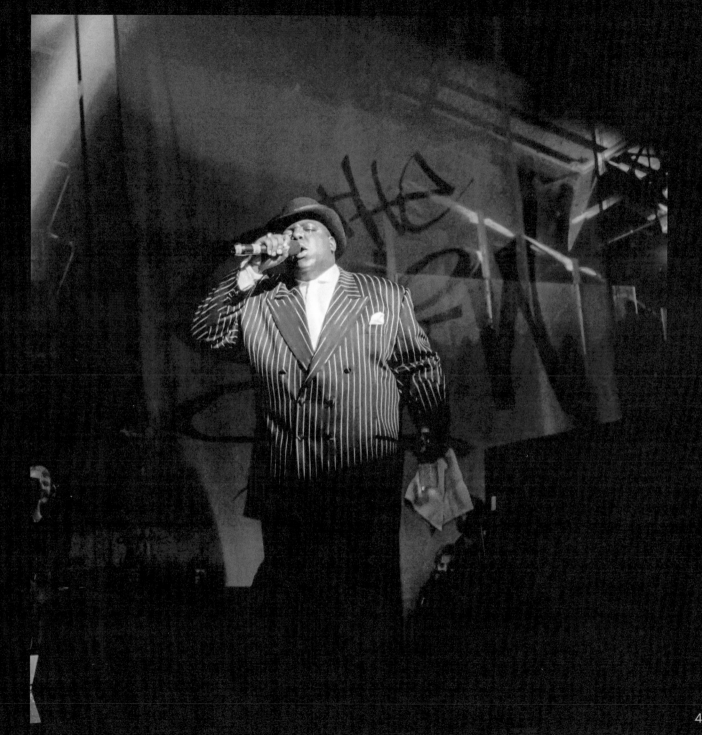

@tdoteric

A Note From the Author

In the 90's, I photographed the world of Hiphop as it began to shift. Taken at a time before the internet, email, GPS, social media, digital technology, and cellphones, this collection highlights captured moments of now-legendary artists as they were on the rise to becoming Hiphop-culture icons.

I maintained and grew a career because I managed opportunities that allowed me to be a part of the fabric of the creative process without inserting myself into it. My relationships with people or the subjects I shot were from a space of comfort, yielding visual representations of unguarded moments usually reserved for close friends and family.

Throughout the 90's, I would commute by bus or train from New Brunswick, NJ to New York City. I skated around the city or used the subway to shoot or attend business meetings with record labels and magazines, as a part of my daily routine.

When opportunities arose, I would seek out and shoot concerts, music video sets, industry only events, and editorial assignments. Eventually, I nurtured these relationships into unfettered access that allowed me to move freely around industry events and to meet newer artists.

In my second year as a New York photographer, I developed outlets to sell my photos: magazines, record labels, photo stock agencies, and private buyers. I paid for everything out of my pocket, so every shot mattered. "Only take the shots you need," was my motto.

Because of the chaos of the pre-digital 90's, photographs (negatives, slides, and prints) that were not chosen by magazines or record labels went into my archive (filing cabinets) and sat for years.

My photos reflect how I saw the artists as everyday people, with personal stories and different senses of the media circus around them. These captured images show another side of the artists, as individuals exposing a genuine, unguarded moment in a single frame, each photo showing one side of the story that was 90's Hiphop.

This endeavor would not have been possible without the patience and support of my amazing circle. I am deeply appreciative of the support from family, friends, colleagues, and the @tdoteric community.

Rare & Unseen Moments of 90's Hiphop : Volume One
by T. Eric Monroe

Produced by:
T. Eric Monroe
Nora Tofigh

Layout by:
Nora Tofigh
Ahsan The Golden Child

Copyediting by:
Shari Nacson

Printed in the USA
CPSIA information can be obtained
at www.ICGtesting.com
LVRC102259080124
768460LV00019B/140

9 780578 527116